# Clarke, Petit and St Mark's

## A 19th Century journey on the Isle of Man

Front cover: Detail of picture shown p4
Back cover: *Tynwald Hill,* 13x13cm, c1830s

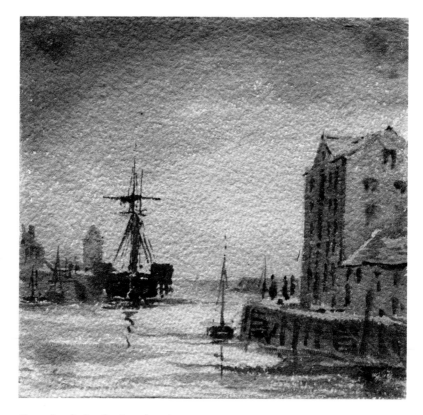

Above: *Douglas Landing Stage from the Tongue,* 12x13cm, c1830s

Published and Distributed by RPS Publications, www.revpetit.com,
enquiries@revpetit.com

ISBN 978-1-9164931-1-7

Designed by Sarah Garwood Creative
Printed by Pensord Press Limited

*"'The evil that men do lives after them, The good is oft interred with their bones'.*
*This in the case of the Rev. John Thomas Clarke will be reversed,*
*for the good that he did at St Mark's will live for ever,*
*and time itself will not obliterate it."*
William Harrison, 1878 [1]

## Contents

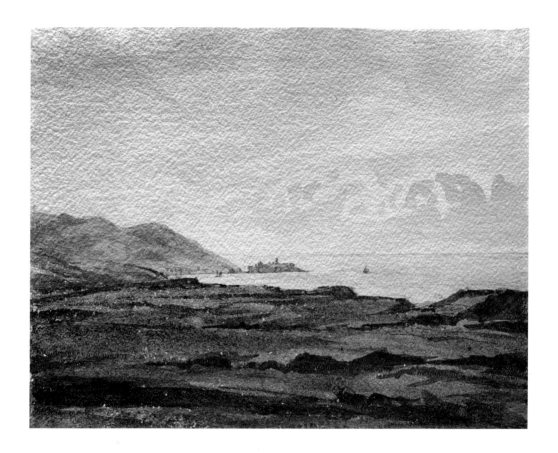

Above: *View of Peel Castle,* from above Lhergydhoo, 20x25cm, 1843
A typical Petit landscape, deliberately avoiding bright blue skies, and any artistic licence.
It can be verified for accuracy today.

This is on the traditional footpath from Peel to Manannan's Chair. From the car park on
the Lhergydhoo road, half a mile before Knocksharry, grid ref 275852, the path starts 50
metres down the road. Walk uphill 15 minutes to where a gate breaks the hedge. Petit
often painted from footpaths.

# Clarke and Petit – History and Justice

---

*"God grant that I may lead a useful life."*
John Clarke journal entry 2nd June 1819 [2]

---

So wrote John Thomas Clarke (1798-1888), chaplain of St Mark's from 1828 to 1864, when he was aged 20. Clarke used to be famous for his development of St Mark's. When he arrived it was to one of the poorest positions in one of the poorest villages on the Isle of Man. When he left in 1864 the village and the chaplaincy had been transformed into one of the most attractive. However, now he has been nearly forgotten.

A similar fate befell John Louis Petit (1801-68), his supporter, friend for four decades and in his day nationally famous for his art and his architectural ideas. Then Petit's art was lost for over 100 years. His views of the Isle of Man, one of the most important series of works by a visitor, have never been shown before.

Clarke's achievements and Petit's art of the Island may seem distinct, but one without the other would only be half the story. Petit came in order to visit Clarke and was Clarke's greatest supporter.

Together they created what is still one of the most architecturally beautiful villages on the Island. Then after apparent disgrace, Clarke, in his seventies, went on to save Petit's church in Wales, for his then dead friend. This booklet recovers what Clarke built and Petit painted.

Determined, modest men or women who strive to do good, caring little for fame or wealth, can contribute to history in ways that have greater relevance to us today than the more powerful and famous. The 250th anniversary of St Mark's foundation is a good moment to tell their story, and correct a little historical injustice.

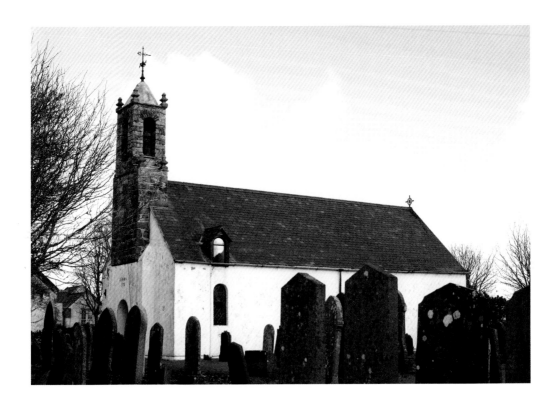

Above: St. Mark's Church

# Clarke's Transformation of St Mark's

*"At one period St Mark's was like an outcast among the churches [of the Island]…Never was a clergyman of the Church of England appointed to a more deplorably wretched situation in the church than at St. Mark's."*
John Thomas Clarke, 1863 [3]

This was still the time when the church was central to a community. If the church was in a terrible state, it was almost certain the village was too, and vice versa. St Mark's had been in decline for 25 years when Clarke was appointed.

The breadth of Clarke's achievements is astonishing, even now. During his 37 years Clarke renovated the chapel; built the parsonage, the school and Sunday school, sundry other houses and dwellings for school teachers and farm tenants, farm buildings and the first two of the four cottages to the right of the church; organised roads and bridges leading to the village from all directions, two post offices and the best village library on the Island; transformed the Glebe lands with 5km of fencing and uncounted tons of rock

clearance; and left a benevolent Society, with 200 members and a fund of nearly £1,000.[4] If that was not enough he was also amateur doctor to his flock, increasingly proficient after his son completed medical training and advanced to be senior medical officer at the Island's hospital.[5]

All this was completed to the highest standard on the Island and with greater economy, as testified by the Bishop, independent assessors and the parishioners themselves.[6]

On his departure villagers held an event to thank Clarke for all he had done. The speeches were published in full in the local newspapers. Extracts convey the emotion of the occasion:

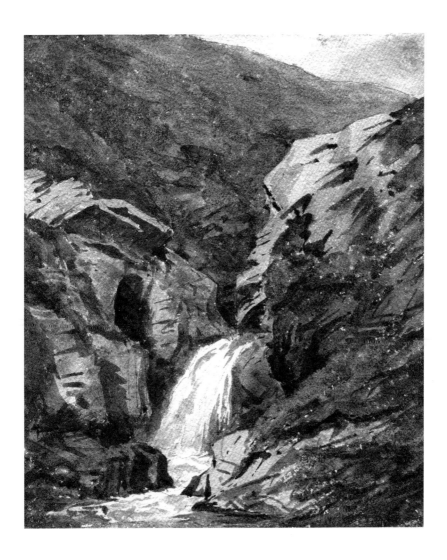

Above: *Rhenass Waterfall,* 25x21cm
This scene has not changed at all and can be reached by a
pleasant walk from the car park on the A3 at grid ref 295843.

*"...these are some of the causes that demand our lasting gratitude...and we believe that while we express our feelings, we express the sentiments of all the inhabitants of the district of St Mark's."* [7]

―――――

"We can remember, sir, when you first came among us, the uncomfortable and un-comely state of our chapel – not only in appearance but in reality; we can remember its clay floors and unfinished pews, which especially in the winter season, rendered the place almost unfit for worship; but mainly by your efforts we soon had, and still have, a boarded floor, and our chapel otherwise beautified...and our chapel-yard much improved...

We can remember the glebe of St Mark's almost covered with gorse and granite rocks...[now] cleared and enlarged, for ever of vastly enhanced value to your successors...

We can remember our roads almost impassable; but owing chiefly to you, we now have very good inter-communication...a post office established...Glebe land cleared and expanded, with drainage and fences...

We can remember about eighty of our children (as the diocesan of our Island can testify) daily cooped up in our then half-light, clay-floored school-room, whose area was only 16 feet by 14 feet, which circumstance in itself was enough to engender contagious disease among them; but by your strenuous efforts our now well-lighted, commodious schoolhouse, with boarded floor... has been built...

We reflect with pleasure on the alacrity with which you at all times responded to the wants of the sick in this neighbourhood..."

(From an address by Humphrey Mylchreest, chairman of a specially formed parishioners' farewell committee, 9th February 1864) [7]

All this bettered the lives of every single inhabitant, and by implication, each of their descendants alive today. In one sense the good lives on. St Mark's is still one of the most beautiful, and indeed prosperous, villages on the Island. Even the lovely little chapel is still open, at a time when many have fallen into ruin or been sold. All descendants of the region benefited from his efforts.

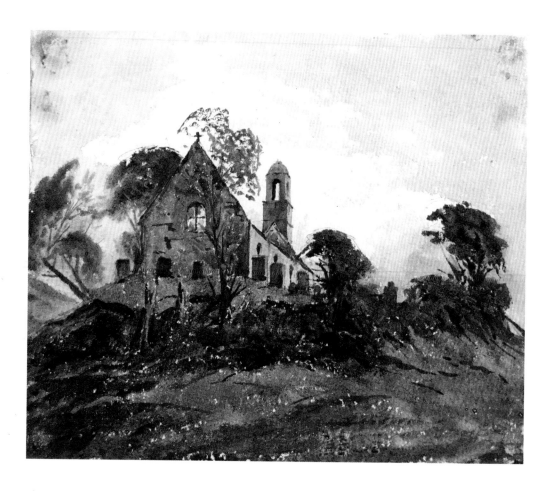

Above: *Old Chapel,* Ballure, 18x22cm, 1843
An example of a chapel fallen into ruin, and subsequently sold for private use.
Possibly a unique picture of it prior to restoration.

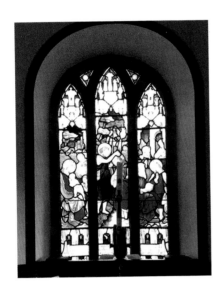

Above: The East Window, photo S. Christian

Yet there is a noticeable absence from the ceremony at which these speeches were made and from the list of contributors to Clarke's parting gift. No member of the clergy is reported as being present or contributing.

The mystery is deeper. A year later there were far more elaborate celebrations attended by the good and great congratulating Clarke's successor, who had been in place barely a year, for some of what Clarke did.[8]

In 1878 William Harrison (1802-84), Isle of Man historian, wrote an entire volume about Clarke's achievements to try to ensure they were not forgotten. In 1899 the East Window of the chapel was put up to Clarke's memory by his family. However, the inscription on the window itself is scarcely visible. The prominent brass plaques in the church are to others who did far less. The parish website, while mentioning Clarke briefly, describes the unusual beauty of the village and the window without connecting them to him.

An explanation for all this is needed. But first why St Mark's is still exceptional.

*"If you know St Mark's you'll know how the character of the village
has something unique and almost indescribable about it."*
Malew parish website 2021

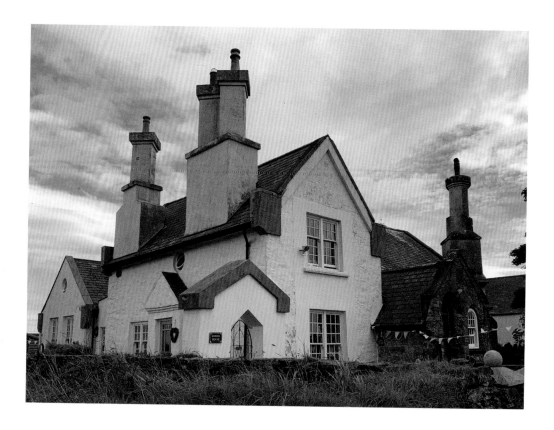

Above: The St Mark's Old Schoolhouse and School
Opposite: The row of cottages

# Architectural Character and Petit

The character of St Mark's comes from the schoolhouse to the left (opposite), the elegant chapel in the middle and the row of cottages to the right (shown below).

The combined School and Schoolhouse was completed in 1846. It is a remarkable piece of architecture. It would be hard to find a nicer example of modern (ie not mock Gothic) Victorian architecture for a village public building on the Island. Not surprisingly, those who subscribed increased their subscriptions on seeing the money so well spent.

At the time it was pronounced:

*"...the neatest and most complete on the Island".*[9] The building was registered for protection in December 2000. The registration document notes that the style is quite uncommon in the Island, specifically mentioning the chimneys (and likewise notes the church belfry), continuing:

*"There is no record of who designed [it]...but it is reasonable to assume that Rev Clark[e] played no small part in deciding its final form."*[10]

However, someone else, a learned architectural designer, was close at hand.

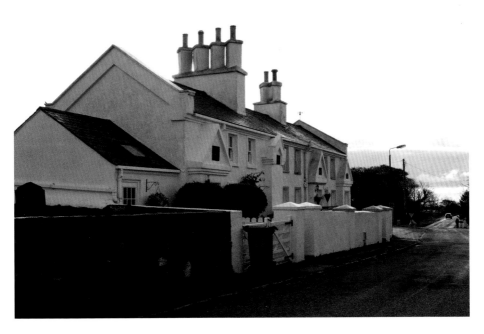

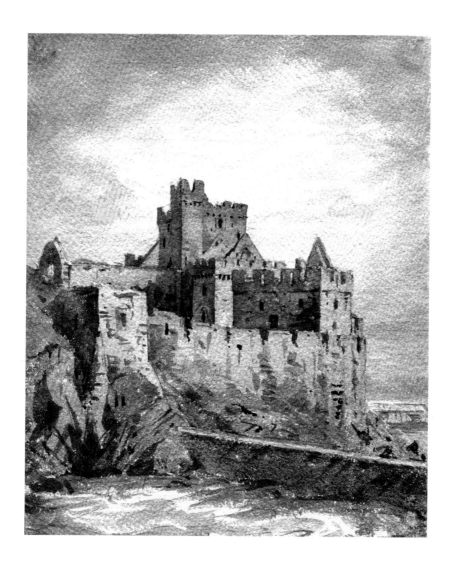

Above: *Peel Castle,* 26x21cm, c1843
Right: Illustration from *Archaeological Journal,* 1846

Petit published 15 articles in the *Archaeological Journal* besides delivering 10 other papers which appeared in their annual transactions. During his visits Petit gathered material for an article on St German's, see p.40.

In 1841 Petit had published a nationally acclaimed book, *Remarks on Church Architecture*, arguing against Gothic and for modern methods, building on previous traditions. Respected academics during the 1840s hailed it the best book on architecture so far written,[11] which he followed up with *Remarks on Architectural Character* (1845).

Petit, accompanied by his sister Emma Gentille Petit, visited the Island, perhaps not for the first time, in 1843; and Petit came again from 1st to 15th October 1845.

The school exactly represents Petit's ideas: Manxish yet modern. Interesting yet not expensive. Petit often contributed design ideas to others. He visited Clarke just as the funding and designs were getting going. It is hard to imagine that he would not have got involved in this project. Clarke would certainly have discussed it with his main English benefactor and friend, and Petit would have enjoyed giving advice including design ideas.

However the design came about, the result is one of the most interesting and beautiful examples of a simple village public building. A credit to both men and all who paid for it.

There may be more of Petit's influence. The chapel itself was originally built in 1772. It is similar to others on the Island, but a little different because of its elegant belfry. The original belfry was squatter and differently positioned, as a picture from 1834 shows.[12]

Petit was an authority on bell towers, turrets and belfries, having written about continental ones in *Remarks,* and an article on some Gloucestershire examples in 1844. Later the bell turret would be the central feature in his design for the Caerdeon Chapel, nr Barmouth, Wales.

In 1854-5 Clarke commissioned a new bell for the chapel. The turret would have to have been rebuilt around the new bell.[13]

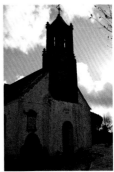

Above left:
1834 drawing

Above right:
In 2021
Photo © J Kinrade

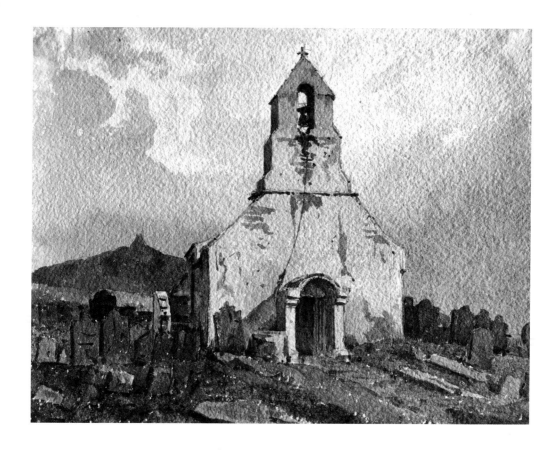

Above: *Kirk Maughold,* 1843, 20x27cm, with the classic Manx belfry
Thankfully surviving and thriving, remarkably the bell-rope still
hangs in the same way across the face of the church.

*"In any case, whether we revive or invent anew, let us aim to go beyond our predecessors, let us aim at some standard of perfection above any which they reached…I may be describing an impossibility; but if we try to reach it, we shall be sure to do something."*
JL Petit [14]

Again we do not know for sure if Petit designed the change, but it is exactly typical of him – preserving tradition but adding beauty.

Harrison told his readers that the Petits were Clarke's greatest supporters, and quoted Clarke's thanks:

*"With regard to myself and my family, [the Petits'] unremitting generosity and unsolicited benevolence knew no bounds. We were invariably treated as if members of their own family, and our pecuniary circumstances uniformly considered…as their own domestic requirements."* [15]

The Petits were just names in Harrison's telling. Certainly they were financial contributors. But the unique character of the village, arising from its architecture, very likely owes something to JL Petit. Petit and Clarke themselves never cared for credit. Proving a direct link now may not be possible. Yet the architectural character of the village lives on and can be felt today. That 'indescribable' feeling is exactly what good architecture provides.

So why has Clarke's name not been better remembered on the Island and at St Mark's, and why is Petit's not known at all either for architecture or his art?

Above: JL Petit *Belfries* 1840, pen and ink drawing for illustration in *Remarks on Church Architecture* (1841) vol I p46

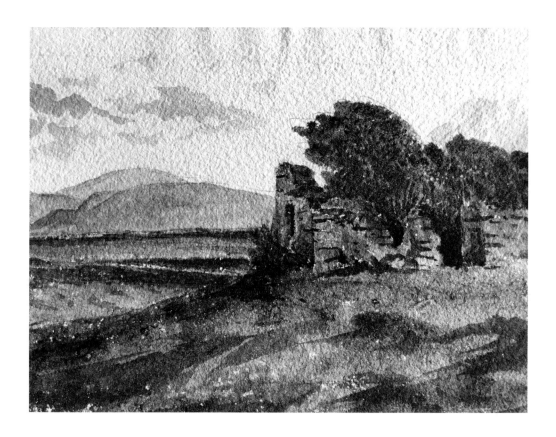

Above: *Island view,* 19x25cm, 1843. An unidentified tholtan reminiscent of the decrepit state of the original parsonage.

# John Thomas Clarke, The Builder Priest

———

*"During 43 years there had been 12 chaplains…*
*At length one was appointed, with energy sufficient to found a bishopric,*
*if his will had been directed that way…"*
William Harrison [16]

———

Clarke was of an ancient landowning Manx family, of the Nappin, Jurby, who traced their roots back to the 13th century. He grew up in relatively well-to-do circumstances, but not to such an extent that he could live off capital, and he was not the first-born son.

In his journal he remarked that at age 19 his parents told him to start doing something productive and he started a private school, before being admitted to train for the clergy. Clarke was a recognised expert in Manx: *"By the age of ten I could speak fluently to my father's tenants, and by the age of twenty I had translated many little English books into Manx."*[17] He was also practical. Apparently having seen a chronometer, he built one for himself in three days.[18]

Attracting a good (sober, honest, hard-working, helpful, as well as sincere in faith) parson depended, to some extent, on tolerable living conditions and income. That has not changed of course. In the 43 years since the chapel's founding in 1772 a vicious circle of decline had established itself. By the time Clarke arrived the living conditions were abysmal:

*"The parsonage-house had been erected on the dampest and most unhealthy site…one third of this building was converted into a cow-house. The stench admitted from the cow-house to the parlour, so-called, was insufferable. So infested was the whole building with rats, that its walls were burrowed from foundation to eaves. One comfort existed – spring water – a spring emitted its current along the kitchen fireside…"*[19]

Right: *Lime Kiln at Scarlett Point*, 13x23cm, 1843

Perhaps the painting of greatest topographical interest. The lime kilns at Scarlett Point produced a major component for construction in the South-East of the Island, presumably including St Mark's. Not long after this picture the kilns were made much bigger and industrialised.

The topography is unusual. The open sea is to the right, while the bay from Castletown curves to the left outside the picture's frame. Now there is a road and ramp cutting across the inlet shown here, across the centre of the picture, going up to the cliff top and the Visitor Centre.

To reach this spot follow the road through Scarlett from Castletown and park in the car park by the beach. Then walk further up the incline to the Visitor Centre and follow the path behind the centre to the other side of the first cutting.

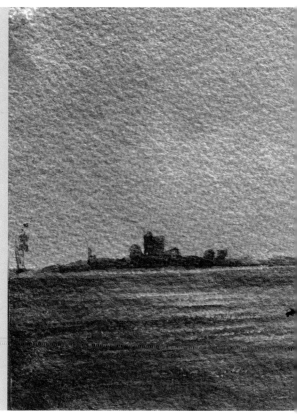

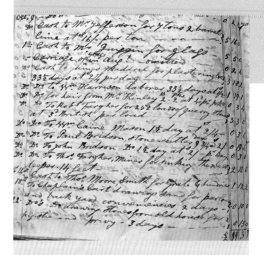

Above: Extract from Clarke's expenditure accounts from October 1829. The third line shows 7 tons of lime bought at 16s per ton. Midway, a consignment of hair for 3s 4d. Labour is paid at 1s 2d per day, while craftsmen earned 2s 6d per day (about the same per annum as Clarke).

The building was condemned as unfit for habitation, and unrepairable, in 1828.

The total income in 1827 for the chaplain of St Mark's was £31 6s 9d. Depending on how it is calculated, this is equivalent to under £10,000 in today's money. A vicar could normally depend on £100 in tithes plus a collection - i.e. three to four times as much. No wonder no-one had stayed.

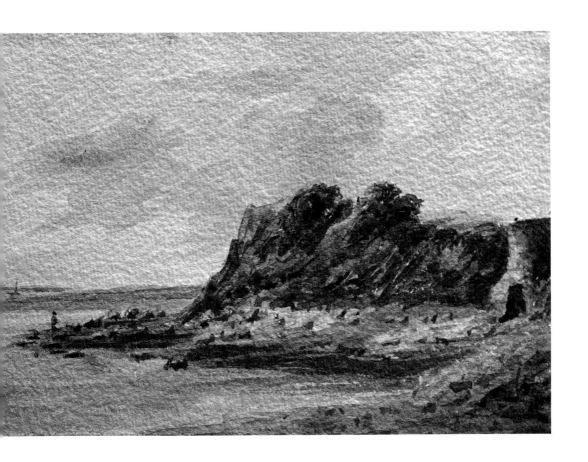

The energy and dedication to turn this situation around is hard to imagine, on top of normal pastoral duties. Clergymen were one of the professional bedrocks of Victorian society. All university students studied theology and, incredibly, about one half took holy orders (though far fewer took up positions).[20] Hardship, fund-raising across England and large-scale project management were not expected.

One can easily imagine the jealousy and criticism that Clarke's success caused from what was described once as *"going a begging"*.[21]

*"The whole building has been delayed thanks to Mr Holmes* [vicar of Patrick] *interfering like a simpleton with the contract…My own sins are sufficient burden without those of others."* (Clarke writing to Bishop Short, having to answer a petty accusation and explain a delay, 1846)[22]

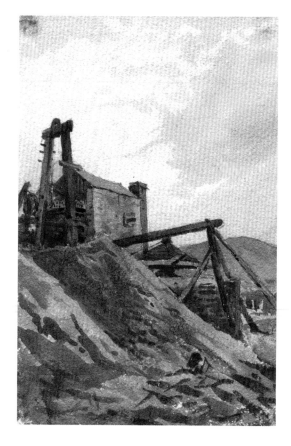

On three occasions, in 1830, 1847 and 1865, Clarke felt obliged to publish in newspapers detailed accounts of all the money he raised and what it had been spent on.[23] They reveal extraordinary details about costs, and his meticulous control of a big project. They make fascinating reading, with contributions from the Queen Dowager and several bishops in one, and details of pennies received from numerous individual Foxdale miners, or free cartage from locals with carts, in another. Clarke also publishes independent attestations of money well spent.

The conclusion must be that the details in the villagers' address given on page 9 are no exaggeration. However, in achieving it all he lost popularity with some key colleagues.

By 1860 income was at the level of a vicarage, and the parsonage was the best dwelling in the diocese. Clarke was master of all he surveyed, nicknamed the Patriarch of St Mark's, according to Harrison. Yet he resigned the chaplaincy in 1864. The reason Harrison gives is that he had lost his eldest son and then his wife, Elizabeth Clucas, in 1862. But if grief was the only reason he surely would not have been so poorly treated.

He and his immediate superior, Reverend William Gill, Vicar of Malew, were co-editors of a Manx-English dictionary. Harrison tells us that Clarke was *"not allowed to correct the many inaccuracies which appear in the first part of the work"*,[24] edited by Gill and prepared in the 1860s.

Two appointees rejected the chaplaincy before eventually Gill's son, curate at Malew, transferred to St Mark's for a short while.[25]

In August 1865 there was a remarkable ceremony, by ticket only, 1/- each, purchased from Castletown or Douglas. Bishop Powys and many other important clergy, none of whom had attended Clarke's farewell, congratulated a possibly embarrassed young curate for many of Clarke's achievements. The

*Manx Sun* published an absurd account of it all under the byline of *"a Visitor from England"*.[26] One interpretation is that this was a press release from the Bishop's office. The byline would have made the newspaper's position clear. The news is as much about the *"Visitor"* as the story itself.

Clarke re-published summary accounts for his 37 years later that month, showing that most of what was being attributed to his successor had been started by him. A note by the wardens refuted the implied accusations of neglect.

Clearly there was a conflict at the end. Perhaps nothing more than proud men defending their dignity. This should not be allowed to affect the record. However, Clarke's personal affairs guaranteed that, at the time, it did.

### Isle of Man.

## RE-OPENING OF ST. MARK'S CHAPEL.

*(As reported by a Visitor from England.)*

It would require the pen of the ready writer of old to describe adequately an event which took place last Thursday in the wild and retired district of St Mark's.

For a long time this district stood in need of an energetic leader to surmount the many hindrances such as a scanty and wide-spread population, scarcity of funds, &c. present to the keeping up of a church and its services. About twelve months ago the chaplaincy fell into the hands of an earnest-hearted young minister who in simple reliance on God's help, put his shoulder to the wheel, calling on his rustic population to come and assist him. Neither did he call in vain. His loving words and brave example inspired the hearts and gave strength to the hands of a people, honest and warm-hearted as himself; and to those who witnessed the ceremony which took place at St Mark's on Thursday last, the words of the old prophet seemed to have been fulfilled.—" The wilderness and the solitary place shall be glad for them, and the desert shall rejoice and blossom as the rose."

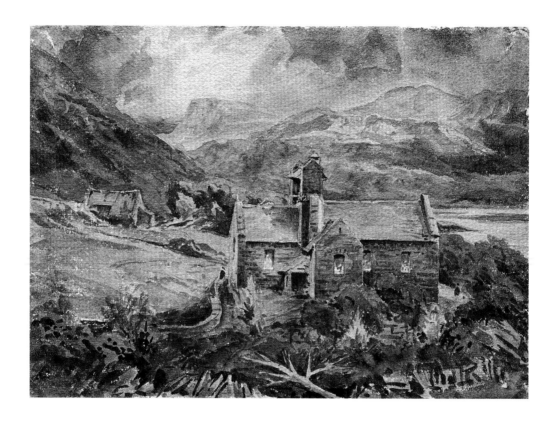

Above: *The Caerdeon Chapel*, 27x37cm, 14$^{th}$ September 1866

The chapel had been built from 1861 to 1862. Shortly after this
picture was completed, Petit visited the Isle of Man for the last
time (see picture page 38).

# A Second Life in Wales: The Caerdeon Years

In 1864 Clarke retired to a rented house in Foxdale. In May 1866 he eloped with and then married a much younger woman, Catherine (Kate) Clucas (1847-1933). Kate was not a near relation to his first wife: Clucas is a common name on the Island. The couple initially registered their marriage at Gretna Green in Scotland,[27] the recognised process to force acceptance of a relationship that did not meet with social approval. Subsequently they married "properly" back on the Island. It is not clear if Clarke even tried to find a position in the clergy on the Island, but if so his elopement will have given his opponents all the ammunition they needed to prevent it.

In November 1866 Petit visited the Island for the last time. Five months later, in 1867, Clarke named his first-born son of this second marriage John Louis Petit Clarke. In February 1871 his possessions and the balance of a lease in Foxdale were auctioned off. By the census date of that year he was a simple curate at the "Seamen's Bethel", St Nicholas, in Gloucester Place, Swansea.[28] But by September 1872, he was installed at Caerdeon Chapel – the only church built by none other than the now deceased John Louis Petit (for his brother-in-law William Jelf). He would soon become the church's first vicar with a living established by Petit's sister Emma Gentille Petit. In the same month Clarke christened a daughter and a son Emma Gentille Clarke and William Jelf Clarke.

Architecturally Caerdeon has been recognised and listed a Grade I building - unique during the heyday of Victorian Gothic for its originality and in perfect harmony with its setting. Exactly the same qualities as we saw at St Mark's.

Was Clarke's position at Caerdeon a last favour by the Petits? Perhaps so and perhaps also the opposite. The chapel had run into a terrible political storm. Jelf wanted to be able to conduct services in his little academic centre in English. This was approved by the Bishop but provoked an outcry with the local Welsh speaking clergy, especially the Rector of the parish in which it fell (Llanaber), John Jones. Numerous suits in the Church and an act of Parliament followed to force the matter in Jelf's favour, which Jones appealed against to the Archbishop of Canterbury.[29] A much more substantive dispute to Clarke's but yet similar. Again proud stubborn men took up positions and dug in their heels. But then the chapel needed to integrate. Who better to understand the difficulties than the Manx-English speaking Clarke with his direct experience of an inter-clerical dispute.

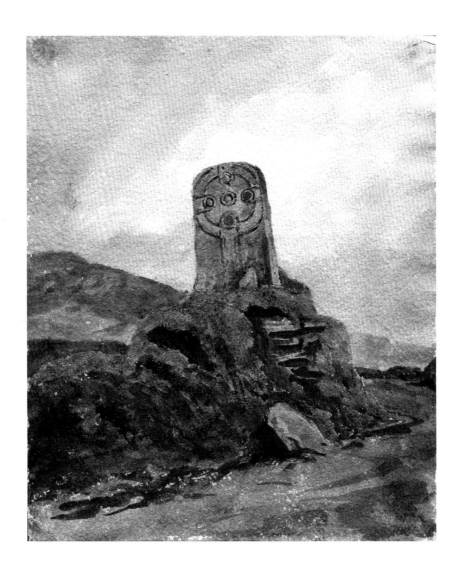

Above: *Port-e-Vullen Cross, Ramsey,* 25x21cm, 1845. Since removed to the Manx Museum.

Clarke's Manx-English fluency, we have seen, had contributed to his trouble. In an 1872 letter Clarke wrote

*"…But the rulers of the Isle of Man are opposed to the Manks; the ministers of the Word of every faith are against it; judges and lawyers are against it; and the youth now brought up more ignorant of the mother tongue than the beasts of the field used to be. In the time of Bishop Wilson and Bishop Mark [Hildesley], no young man could enter the office of the priesthood unless he had good Manks."* [30] A direct attack on Bishop Powys.

Rector Jones would certainly have shared Clarke's sentiment. Within a few years the dispute was overcome. In his first year Clarke started a school. A rectory, schoolhouse and school master's dwelling were built, with thriving school and Sunday school. In 1875 some twenty of the local clergy, including Rector Jones, attended the Bishop in consecrating the church as a separate parish. In 1876 Jones officiated at the wedding of Clarke's sister-in-law, who had been appointed the school teacher. [31] Welsh and English services were being held at Caerdeon and at Llanaber.

Above: Clarke's memorial cross at Caerdeon churchyard, Wales. The inscription reads *"Of the Nappin, Isle of Man"*.

By the time Clarke died, aged 89, in 1888, the church had gone from having no future, to thriving, and would shortly take on a daughter church in the nearby village. The church continued to thrive well into the 20th Century long after many others similarly isolated had closed, eventually in 2019 to be taken over by the Friends of Friendless Churches.

There may be unanswered questions about Clarke's retirement, the reasons for the conflict with Bishop and Vicar, and why he left the Island. These deserve to be forgotten, not the remarkable transformations he made in both the Isle of Man and Wales.

John Thomas Clarke had led a useful life, right to its end.

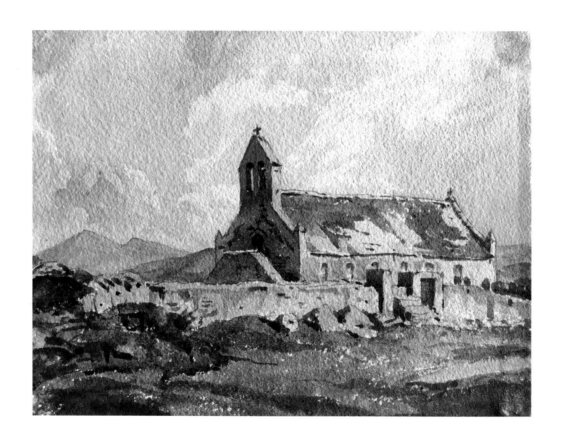

Above: *Old St Runius Church,* 19x25cm, 1843
The former parish church of Marown where BP Clarke was vicar.

# Afterwards...

Clarke had married Elizabeth Clucas (1794-1862) in 1822 and had six children, four of whom survived to adulthood: John, George, Benjamin and Anne. John trained to become a doctor, served as medical officer in China and then won the appointment of chief medical officer at the Island's hospital before dying suddenly in 1862 at age 39. Both surviving sons became clergymen and inherited estates from their mother's family.

George Clarke changed his name to Clucas (quite common on inheriting from one's mother's family). After a degree at Cambridge he took holy orders at Lichfield in 1856. Petit was a prominent citizen of Lichfield, and had served on a committee for the cathedral's restoration a year earlier. George then worked nearby, as a teacher, for 30 years at Repton College, Burton-on-Tent. His son was Sir G F Clucas (1870-1937), Speaker of the House of Keys. Presumably some Clarke descendants may still be on the Island. Benjamin Clarke, Vicar of Marown, later Canon, died childless in 1903; as did Anne in 1907.

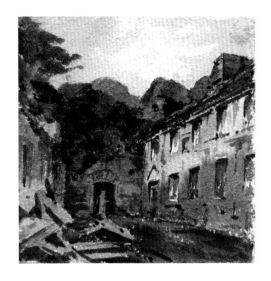

Above: *Water Pump, Douglas,* 13x13cm, c1830s

Clarke and his second wife Catherine (Kate) Clucas had four children. John Louis Petit Clarke changed his name to Lewis and went to America. William Jelf Clarke played hockey for Wales in 1897. However, he did not complete medical training and emigrated to Canada. Caesar, like Lewis, took holy orders, worked as a missionary in Burma and Sierra Leone, and is buried close to his parents at Caerdeon. Emma married Rowland Evans locally. They lived in Burma for a few years in the 1920s but returned and are also buried at Caerdeon. Descendants of both may live in the region.

Kate was left with very little when her husband died, but managed to recover her situation as a landlady in nearby Dolgellau, presumably helped by her children and sister. Clarke's two families were on reasonable terms having met, at least, at Clarke's funeral. Their father's second wife, half brothers and sister were remembered in Benjamin and Anne's wills.

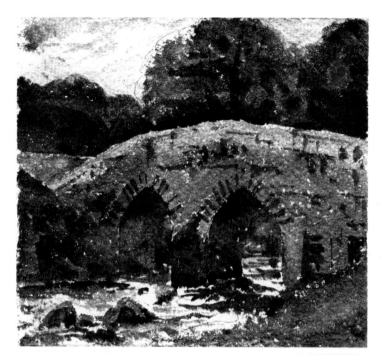

Above: *Monks' Bridge at Ballasalla*, 13x13cm, c1830s

March 16th 1899

Letter from Rev GP Clucas to Rev Holmes

*Dear Sir*
*My brother, Canon Clarke...like myself objects to an additional*
*inscription on a brass near the window, but there is no reason*
*why a brass should not be placed in some other [location]...[a*
*pity that] the chancel should be appropriated to the honour of my father's successors, Mr Gill and Mr*
*Lupton neither of whom did anything for the place in comparison with what my father did...*

*I very much value the loyalty and kind feeling of my own and my father's friends at St Mark's and they*
*have it seems helped in the present work...My objection to the brass was that it seemed superfluous,*
*but they have a right to be recognized in the matter...*

# Of Glass and Brass

In June 1898 the Chaplain of St Mark's, the Rev AJ Holmes, contacted his colleague Canon BP Clarke, following a suggestion by parishioners to commemorate John Thomas Clarke's work with the East Window. Benjamin and his brother and sister decided to take over the funding of the window and dedicate it to both their parents' memory,[32] leaving the parishioners to put up a brass plaque commemorating the work Clarke achieved. The window is a beautiful adornment to the church, where previously there was just plain glass. However, the inscription is easy to miss, and the plaque nowhere to be seen.

Perhaps more by accident than design the four brass plaques by the lectern are more prominent. Two are to Clarke's successors, *"neither of whom did anything for the place in comparison with what he did"*,[33] and one to an honourable gentleman who unveiled one of the other plaques. The fourth notes the stonework for the window, a strange relic of what was planned.[34]

Right: The four brass plaques. The top two to later chaplains.
The bottom left plaque, bizarrely, just reads:
*"The Stonework of the East Window erected March 1899"*.

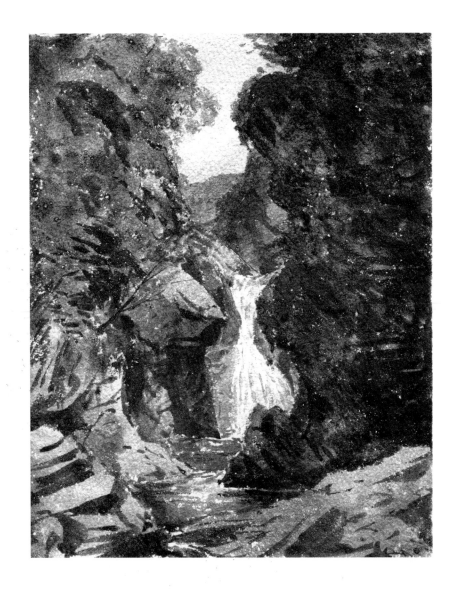

Above: *The Glen Maye Waterfall*, 26x20cm, 1843
Still the same, and easily accessed from the pub car park.

The result, whether intended or not, is that there is nothing obvious that commemorates Clarke for a casual visitor to the church or to the centre of the village, while there are plaques to the less worthy, or which are obscure. There are many ways in which this situation might be corrected not necessarily within the church. Since Clarke's achievements pertain to the group of buildings an interpretation board outside might be just as appropriate.

Does all this matter now? One might argue that Clarke, and his children, are dead and seemingly forgotten. However, injustice, even historical injustice in a small village, rankles until it is corrected.

Let us give the last word on Clarke to Kate, his second wife, in her letter to Chaplain Holmes:[35]

*April 26th 1899*

*Dear Mr Holmes,*

*I do not address you, or think of you as quite a stranger – having heard much about you and your good work from the Kermodes of Kionslieu.*

*Will you accept my mite (£1) towards the Memorial window for my dear late husband – I believe that it would be much more if I could afford it.*

*It was a disappointment to me not to have been able to visit St Mark's in September last – but I was in ill health - & have been so on & off since.*

*I rejoice to think at last St Mark's possesses a man who is honourable enough to give credit where it is due.*

*I was not acquainted with Mr Clarke when he lived at St Mark's but everyone who knows or has heard of the good works which he did there, must acknowledge that he deserved the very highest praise. Wherever he went he left his mark as regards improvements and although he spent his money in that way - & left me very poor with four young children yet I would prefer it was so – than that he should have lived a narrow selfish sort of life.*

*When he was taken, I had but £13 in the whole world, but Providence has been wonderfully good to me - & I often say that it must be owing to Mr Clarke's great work.*

*Kate Clarke*

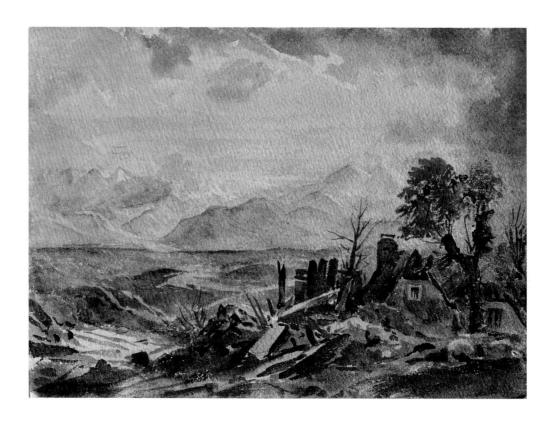

Above: *Near Pau, France,* 27x37cm, 1859
An example of his most radical work

# John Louis Petit, A Singular Artist

*"He was of a noble, generous nature, both as a scholar, as a gentleman,
and as a most original artist…as noble-hearted a man as ever lived"*
Sir George Gilbert Scott [36]

The Reverend Petit was the eldest of ten children. Sufficiently wealthy, he resigned from working in the church in 1834 to focus on his twin passions of architecture and art. In architecture he doggedly persisted in pointing out that the Gothic Revival was doomed to fail.

*"Is it too much to say that the result of this fashion (hitherto) is that we have spoilt our old buildings by making them look new, and our new ones by trying to make them look old?"* [37]

Petit was one of the most popular writers and speakers in the 1850s and 1860s, freely contributing designs and ideas to others. However, his contributions have been downplayed by those, such as Sir Nikolaus Pevsner, who preferred to describe the 19th Century as solely historical, the century of Pugin, Ruskin and Scott.

Petit painted obsessively all his life, exhibited at lectures but never sold his pictures. His church sketches alone would make him the most prolific and expert of artists of medieval churches across Europe. But his landscapes are artistically more important. He foreshadowed Impressionism when the rest of British Art turned historical with the Pre-Raphaelites. In one contemporary book he was ranked among the ten greatest outdoor watercolourists.[38]

Clarke and Petit met probably for the first time in London in the 1830s when Clarke went on trips to England to raise funds for St Mark's. Petit then visited the Island several times, especially in the early 1840s.

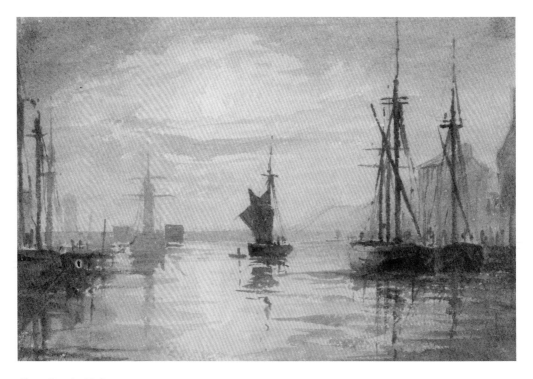

Above: *Douglas Harbour*, c1843, 16x24cm
© Manx National Heritage.

Thirty-two Island pictures are known, of which twenty-eight have been traced. All but one of the known Isle of Man works are from these early visits and before his more radical work in the 1850s (see previous, p34). Yet even then they still reflect his focus on what is real. *"Artificial picturesque,"* Petit would write, *"is worse than useless."* [39]

During his lifetime he often gave away works and Clarke is very likely to have had several. Petit's last known visit was in 1866, two years before his death. Petit had come to see Clarke. Presumably they talked about the difficulties at Caerdeon from where he had come, and the difficulties that Clarke had faced in recent years.

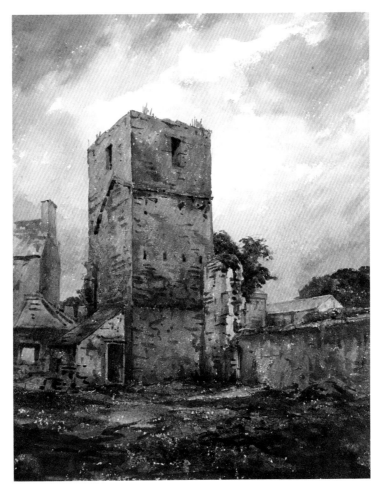

Above: *Rushen Abbey* (inscribed on mount), 1845, 32x23cm
Petit might have been considering it as the second subject for an article.

Clarke's second wife was pregnant with the boy who would subsequently be christened after Petit. This may have been the last time they met.

When Clarke came to take up the position at Caerdeon, it was Emma Gentille Petit, Petit's sister, who would donate £1,500 (about half her total wealth) to provide the living for the first vicar and in memory of her brother. All three are as unknown at Caerdeon as Clarke is at St. Mark's.

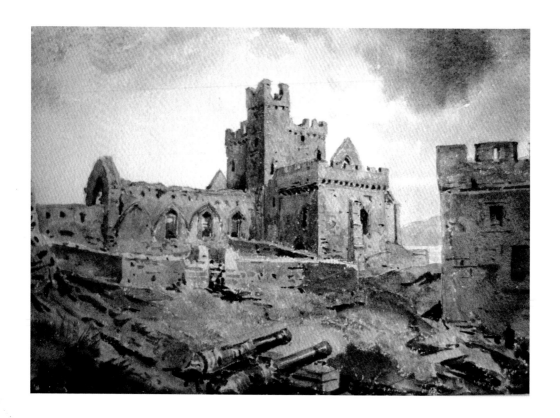

Above: *Peel Castle*, 26x37cm, 12th November 1866
This picture was taken perched on the rampart directly
in front of the causeway, eight weeks after the one of
Caerdeon (page 24). Sixty works, including sketches,
were completed in those fifty days, some no doubt on
the Island.

Petit married unlike his two brothers, although all three died childless. Of seven sisters, three married and have descendants living today. After his sisters died nearly all Petit's art, over 10,000 works, went to a nephew who cared little for them. They were stored and then literally lost. Discovered in an attic they were dumped wholesale in regional auctions in the 1980s and 1990s. A significant discovery in British art was entirely missed and only now can the range and quality of his work, including on the Isle of Man, start to be appreciated.[40]

While there are many great artists of the Island in the second half of the 19th century, there is little before then - only classic "picturesque" views by professionals, or amateurs' souvenirs.[41] Professionals painted on commission or to sell, amateurs for pleasure. Petit painted to show the spiritual beauty of nature, the beauty of churches, and occasionally real industrial scenes others ignored: wholly different motivations from either professional or amateur. His views fill an important niche in Island art just before its own school developed.

––––––––––

**Clarke was practical, Petit's talent was artistic. Yet what they shared was more important: indefatigable energy in the face of obstacles, and never losing determination to do what was right despite the personal cost.**

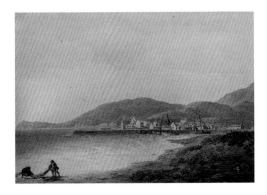

Above left: A professional view: John "Warwick" Smith, *South-East View of Ramsey,* 1795, Manx National Heritage Collection. This copy from *Art of Mann,* edited by A Kelly et al © *Moods of Mann 1996.*

Above right: From an amateur's sketchbook: Emma Cram's illustrated account of her trip to Isle of Man in 1842[42]

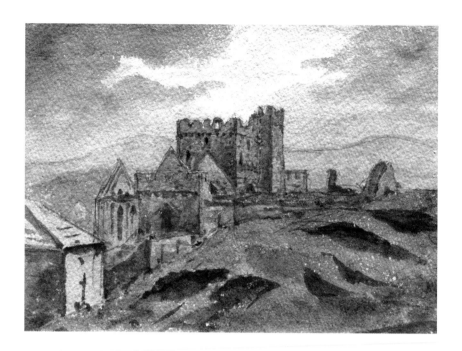

Above: *Peel Castle*, 13x17cm, c1843

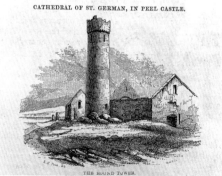

THE ROUND TOWER.

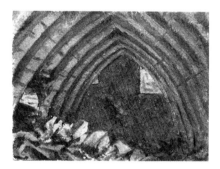

Above right: *Crypt, Peel Castle*, 13x13cm, c1830s
The wall now shows other openings which were
blocked up.

Above left: The fronting illustration for the article by Petit in the *Archaeological Journal*, 1846. Both watercolours on this page, as well as that on page 14, were the basis for illustrations in the article. However, the original of this one was by his sister Emma Petit, who worked closely with him. The title indicates that other subjects might have been planned to follow.

Above: *St Trinian's,* 13x13cm, c1830s

## Acknowledgements

My thanks to seven individuals: Frances Coakley editor of the Manx Notebook website *(www.manxnotebook.com);* Alan Kelly of Mannin Collections Ltd; Sarah Christian of the Manx Archives; Mike Kelly, Pat McClure, and Tim Grass, independent researchers; and Wojtek Szatkowski, my colleague at the The Petit Society. They have all suggested many improvements. Remaining sins, of omission and commission, are mine.

## About The Author

Philip Modiano has been researching John Louis Petit and his circle for four years. Other publications are shown on the website *www.revpetit.com,* including the companion booklet *Hidden Treasure on The Mawddach - The Caerdeon Chapel and JL Petit's Art of Merioneth* (RPS Publications 2022).

# Footnotes

Brief references are given here. For further information see www.revpetit.com under Publications.

1. The Manx Society Vol 28 by William Harrison, 1878, (hereafter 'MS28'), p81. iMuseum ID Number 10493, also published online at www.isle-of-man/manxnotebook

2. iMuseum reference MD 10141 B/1 (MS 08741/1). The journal covers the years 1817-1820 and is the only journal in the Archives. This entry for 2nd June 1819

3. MS28 p28 and p68

4. Manx Sun 13.2.64, p8 and in MS28 p75-80

5. Manx Sun 16.4.1853 for Dr Clarke's appointment

6. MS28 p39-41 and published in 1865 Manx Sun, 26.8.65

7. Manx Sun 13.2.1864, p8

8. Manx Sun 12.8.1865 front page, see p23

9. Manx Sun 13.9.1845, p4

10. The building is registered No 181. The registration form RB1 is at www.gov.im/media/632585/0500181regbldoldschoolhouse.pdf

11. Professor Edward Freeman, The History of Architecture (1849) preface

12. From a set of drawings commissioned by Bishop Ward, and reprinted in John Gelling's History of the Manx Church (1996)

13. Gelling dates the new bell to 1855

14. Architectural Studies in France (1854), p170

15. MS28 p59

16. MS28 p27

17. Clarke letter on Manx language published Manx Herald 1st May 1872

18. Clarke's journal MD 10141 B/1 (MS 08741/1), entry for Wednesday 5th November 1817

19. MS28 p28

20. Petit's Tours of Old Staffordshire (2019) p13, but comes originally from Phillippa Levine, The Amateur and The Professional (Cambridge University Press, 1986) coincidentally also p13

21. Bishop Short's comment is from a handwritten note in MD12 of the Diocesan Archives

22. Clarke Letter 17.09.1846 to Bishop Short MD12 of the Diocesan Archives

23. Manx Sun 23.11.1830 front page; 10.7.1847 p3; and 26.8.1865, the year of claim and counter-claim

24. MS28 preface p xiv

25. Gelling reports Bishop Powys not being happy with Gill appointing his son, but by 1865 he clearly was willing to celebrate the appointment

26. Manx Sun 12.8.1865 front page

27. Dr Pat McClure found the Gretna Green marriage registration dated 30th May 1866. McClure papers with the Petit Society

28. Isle of Man Times 25.2.1871 p8; 1871 Census copy in McClure papers with Petit Society

29. Caerdeon Chapel, Hugh Owen, Journal of the Merioneth Historical and Record Society 160 vol III. Also summarised in Hidden Treasure on The Mawdach (RPS 2022)

30. This letter was first published in English in the Manx Herald, 1st May 1872

31. Isle of Man Times 02.08.1879 p5

32. MS 10855. BP Clarke's letter 9.7.1898

33. MS 10855. GP Clucas' letter of 16.3.1899

34. The intended inscription for the brass which the sons did not especially want is in the same letter of 16.3.1899

35. Catherine Clarke's letter also in MS 10855

36. GG Scott Recollections (2005 edition by Gavin Stamp, pp297-8). A remarkable attestation from Petit's greatest opponent, written some years after Petit had died

37. JLP Architectural Studies in France (1854) concluding chapter

38. Philip Delamotte The Art of Sketching from Nature (1878)

39. From Petit's lecture On Utilitarianism, reprinted in The Builder 26.1.1856

40. See for example Petit, Lost British Pre-Impressionist (Pallas Athene, 2022)

41. Art of Mann edited by Alan Kelly (et al, Moods of Mann Ltd 1996). Manx National Heritage online catalogue searched from 1800-1890 in Oct 2021

42. MS 13029

43. MS28 p68

Above: *Landscape,* 13x13cm, c1830s

―――――――

*Though the labour entailed upon me in the accomplishment of such objects has been unprecedentedly great; though my family has been compelled to endure many privations, and my own mind often sunk into the lowest depths of despondency; yet seeing the work now accomplished, and my children so nobly taken by the hand by friends whose friendship the mercy of God procured for us, my heart is so cheered and full of gratitude to God and man, that I would readily engage in the same work over again with as much devotedness and energy as ever.*
John Thomas Clarke [43]

―――――――

# Index of Petit Watercolours